English Cathedrals and Churches

Twelve watercolours from the British Museum

Notes on the plates by Ann Wilson

Notes on the artists by Paul Goldman

Published by British Museum Publications Ltd

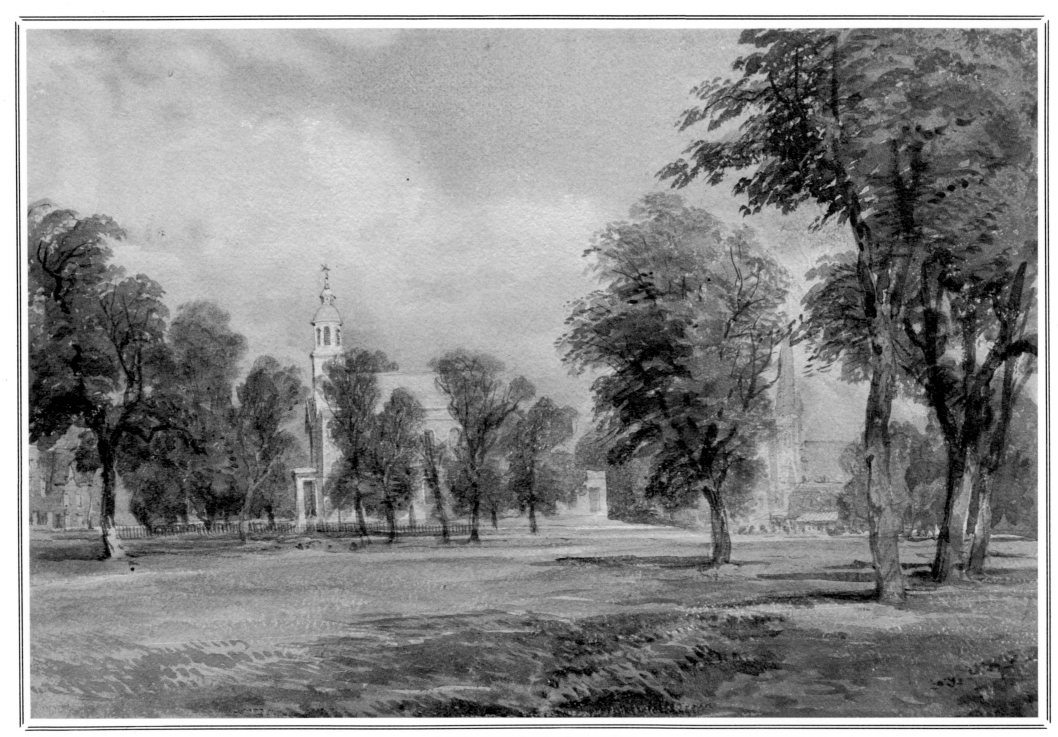

CLAPHAM OLD CHURCH AND COMMON
David Cox (the Younger)

Clapham Old Church and Common

David Cox, the Younger (1809 – 85)
262 × 395mm. 1939 – 7 – 11 – 5

THE parish church of Holy Trinity, Clapham, was built in 1776 in
solid Georgian style and it continues today to give dignity and
charm to the northern corner of South London's Clapham
Common. The elm trees shown surrounding the church in the
painting have since been replaced and a hedge grows along the lines
of the old fencing, which initially proved such a convenient washing
line to the local cottagers that the outraged church beadle obtained
official permission to throw the clothes away. It was also the beadle's
unhappy lot to enforce traffic order among the throngs of carriages
that rolled up to Holy Trinity whenever the Reverend John Venn,
who died in 1813, was preaching. The church contains the wooden
pulpit, slightly cut down, from which this evangelical rector gave
his rousing addresses to a congregation that included the slavery
abolitionist William Wilberforce, who lived in the parish from 1797
to 1807.

A new chancel and Lady Chapel have been added to the church's
plain and attractive interior, which has galleries running along three
sides, but otherwise little has radically changed within or without.
The view through the trees, to the right, includes the splendid spire
of St Mary's Roman Catholic Church, built in 1851 and still today
one of Clapham's clearest landmarks.

David Cox is sometimes criticised for not attaining the heights
reached by his famous father. However, *Clapham Old Church and
Common* shows a delicacy and a feeling for colour, and although
lacking much of the drama of his father's work, the younger Cox
had an ability to produce much that is both competent and
charming. He travelled widely throughout the British Isles and
exhibited regularly at the Royal Academy. At the time of his death
he was an Associate of the Royal Society of Painters in
Watercolours.

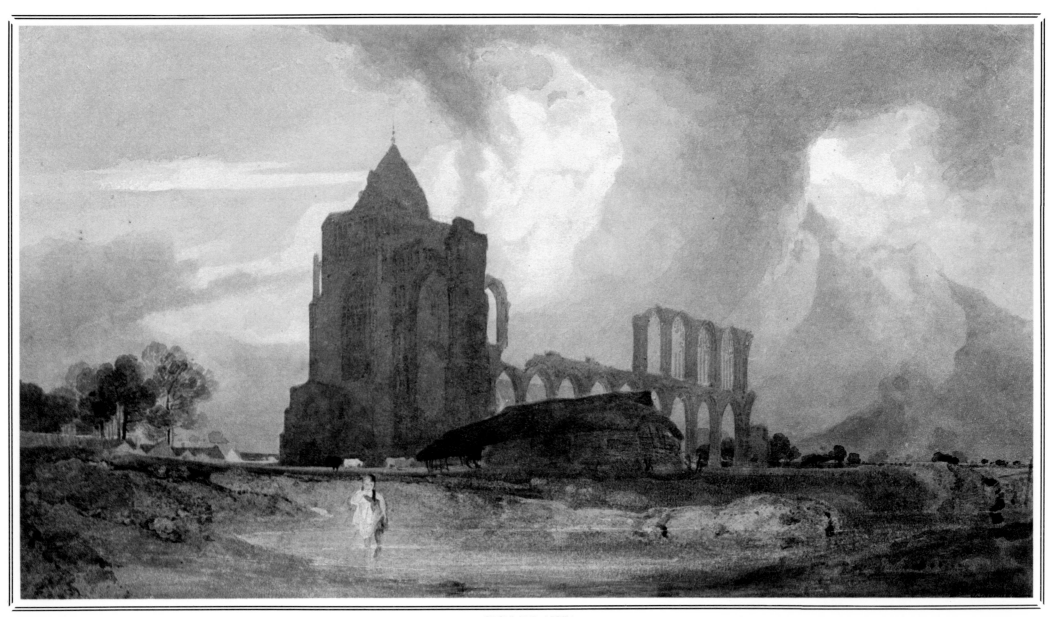

CROYLAND ABBEY

John Sell Cotman

Croyland Abbey

John Sell Cotman (1782 – 1842)
294 × 537mm. 1859 – 5 – 28 – 118

THE magnificent half-ruins of the once famous Benedictine Abbey of Croyland – or Crowland as it is now better known – lie in the fen country just within the southern Lincolnshire border. The Abbey's romantic origins go back to 699 when a young Mercian noble, Guthlac, abandoning his wealth and his violent past, came to live as a hermit at Crowland, then a dry patch of ground within dismal, remote swampland. His body lies buried beneath the Abbey, which was founded after Guthlac's death in 714 by King Ethelbald of Mercia in gratitude for Gutlac's spiritual guidance.

The Abbey was destroyed three times by fire and each time rebuilt, with ever increasing splendour, but at the Dissolution much of the building was demolished. By the middle of the eighteenth century only the splendid fragments seen today, and in this painting, were left of the western part of the church. These include the Norman nave and the glorious west front which has a fine thirteenth-century doorway with richly carved, fifteenth-century panelling above. The north aisle and the tower survive intact and this part was, and is still, used as the parish church. In recent times the swamps have been drained but the Abbey still gives an impression of remoteness and grandeur as it rises clear of the modern, high-banked flood banks and the wide streets of Crowland.

John Sell Cotman was born in Norwich, but moved to London, where he joined the group of artists under Dr Monro's 'tuition'. He spent many years as a drawing-master and although arguably the greatest of the English watercolourists after Turner, he never received the recognition he deserved and his life was a constant struggle against poverty. From 1834 until his death he was drawing-master at King's College School, London.

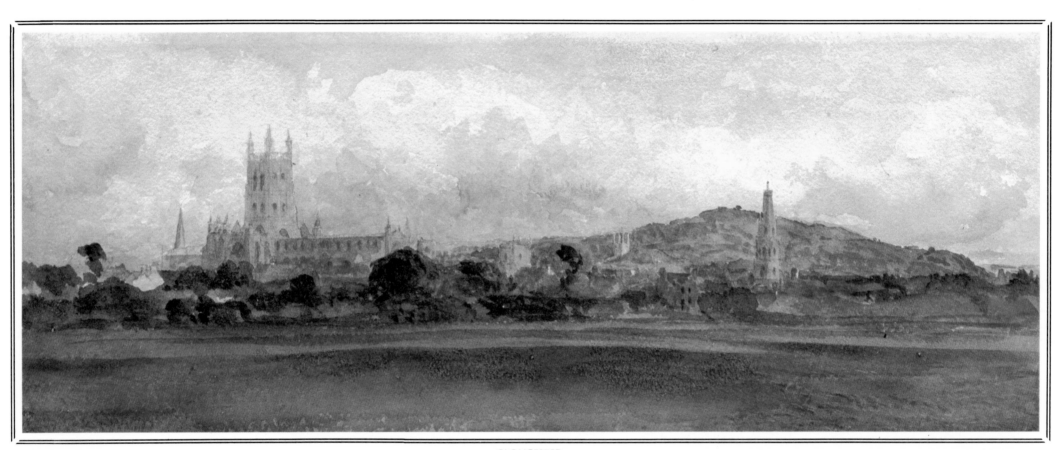

GLOUCESTER
Peter de Wint

Gloucester

Peter De Wint (1784 – 1849)

147 × 384mm. 1886 – 6 – 7 – 10

THE ancient town of Gloucester stands on the River Severn, a guardian of the west and an important city to the Romans, and the Saxons after them. But it was during the Middle Ages that Gloucester became closely associated with royal events and reached its greatest fame and wealth. The Cathedral is the town's crowning glory and dates back to 1089 when the foundation stone of a new Norman Abbey was laid. Money began to pour in to the Abbey's coffers from the pilgrims who flocked to the shrine of the murdered King Edward II, whose body had been brought to the church by the astute Abbot Thoky in 1330. With these riches, the Norman Abbey was transformed in the thirteenth and fourteenth centuries, introducing the beautiful and revolutionary building style known as the Perpendicular. The impact of Gloucester's vast east window, with its glorious vertical tracery, and the soaring stone cage enclosing the old choir is dazzling; equally beautiful are the cloisters where the soft light plays on the superb stone lacework of the fan vaults, the first vaulting of its kind.

A network of roads and railway lines has replaced the green meadows south of the city shown in this painting, but there is still an almost unobstructed view of the Cathedral's splendid Perpendicular tower topped by slender turrets and pinnacles, with the towers of Gloucester's many old churches scattered around it and the Cotswold Hills rising in the distance.

Peter De Wint was to have followed his father's profession as a doctor, but he turned his back on this assured future to become a painter. In 1809 he entered the Royal Academy Schools. De Wint's gifts were encouraged by meeting John Varley and by his association with a gifted group of artists who gathered around Dr Monro to paint, copy and study in a convivial atmosphere. He worked almost exclusively in England, and taught various amateurs, although none of his pupils became distinguished. He died in London on 30 June 1849 and was buried in the Chapel Royal of the Savoy.

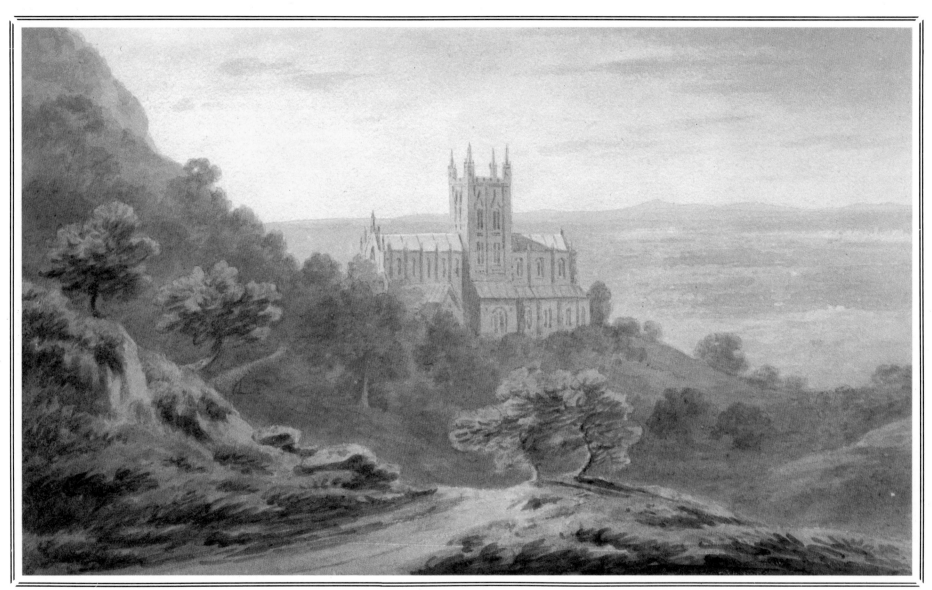

MALVERN CHURCH

John 'Warwick' Smith

Malvern Church

John 'Warwick' Smith (1749 – 1831)
138 × 230mm. 1958 – 7 – 12 – 385

THE great Benedictine Priory of Malvern was founded in about
1085, but though the church's Norman base remains, what is seen
in this painting, and today, is the complete rebuilding, between
1400 and 1460, in the splendid Perpendicular style derived from
Gloucester Cathedral. Within a century the newly built Priory
came under Henry VIII's axe, the outer monastic buildings were
demolished, along with the church's Lady Chapel and south
transept, and the church was only saved from total ruin because the
poverty-stricken local villagers managed to scrap together £20 to
buy it from the crown. Thanks to them and to the extensive
restoration work done after 1860, much of the church's original
glory can be captured today. The beautiful interior glows with
colour from all the fifteenth-century stained glass, and among the
church's other delights are the medieval tiles – over a thousand of
them – for which the Priory was famed. When Malvern became
popular for its water cure in the nineteenth century, the town
blossomed and the Priory Church now rises above surrounding
buildings, with the lovely rolling countryside encircling the town.

John 'Warwick' Smith, who became known as 'Warwick'
Smith on account of the patronage of the second Earl of Warwick
(who subsidised his stay in Italy from 1776 to 1781) was a topo-
graphical artist especially admired during his own lifetime. His
contemporaries praised him for his colouring which was thought
to have introduced a new force and richness into watercolour art.
Smith was a member of the Water-Colour Society from 1805 to
1823, exhibiting regularly and holding several offices.

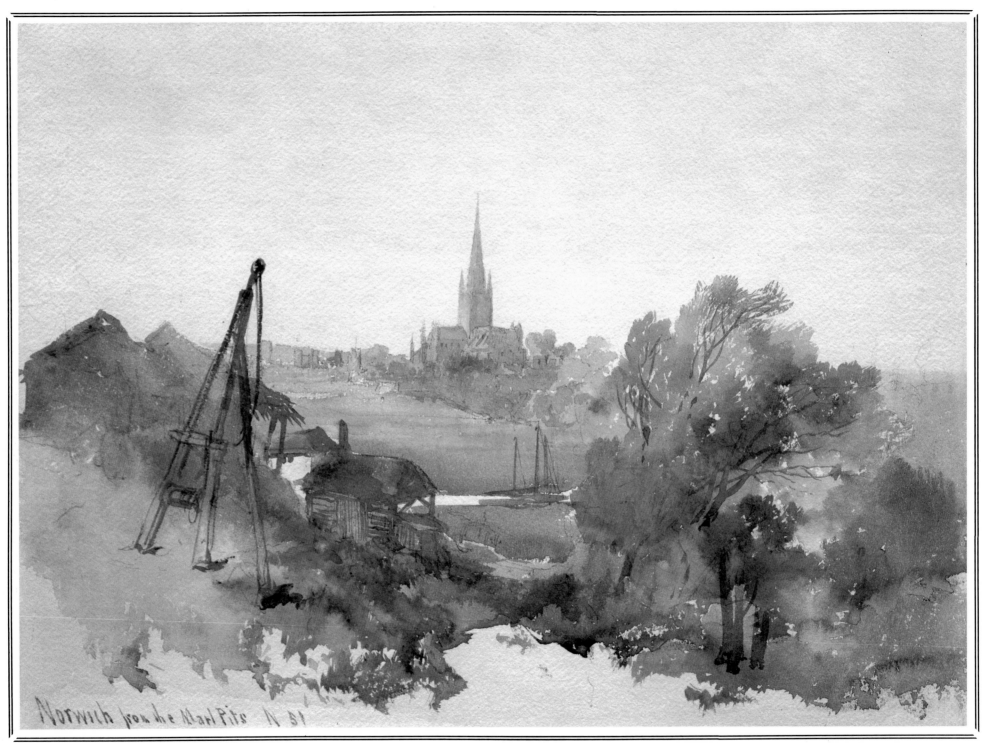

Norwich from the Marl Pits N 51

NORWICH FROM THE MARL PITS

Edmund John Niemann

Norwich from the Marl Pits

Edmund John Niemann (1813 - 76)
354 × 488mm. 1899 - 7 - 13 - 3

THIS view of Norwich Cathedral from the south-east delighted the nineteenth-century writer George Borrow: 'Gazing from these heights, the eye beholds a scene which cannot fail to awaken, even in the least sensitive bosom, feelings of pleasure and admiration.' Borrow's 'rich meadows of the brightest green' are now largely overgrown with houses, and the deep pits dug to extract the chalky clay – or marl – for use as fertilizer are no longer familiar landmarks, but the sweeping view across the valley, with the narrow River Wensum running through it, can still be appreciated today from the high ground of Mousehold Heath.

From here the great expanse of sky for which East Anglia is famous makes a particularly beautiful backdrop to the graceful fifteenth-century spire, 315 feet high, of Norwich Cathedral. It rises from a finely proportioned Norman tower, the Cathedral's striking central feature. The building is essentially Norman and retains its impressive round apse. The interior, superbly furnished, with hundreds of finely crafted roof bosses, has a magical quality: light pours in from the high windows, to be scattered among the massive Norman arcades and low aisles counterbalanced in beautiful visual harmony by the slender, soaring columns.

Edmund John Niemann became a clerk at Lloyd's at the age of thirteen, but in 1839 decided to devote himself to art. He exhibited for many years at all the main London centres, including the Royal Academy. At his best, his skill was that of the true watercolourist, for in *Norwich from the Marl Pits* he makes full use of the textured paper to provide the white highlights. Indeed he knew exactly where to place his paint and where to leave the paper blank to speak for itself. Even the cream colour in the foreground is merely the lightest application of a wash which still permits the eye to appreciate the texture of the paper beneath.

Aldenham Church, Hertfordshire

Henry Edridge (1769 - 1821)
326 × 459mm. 1872 - 2 - 10 - 6

THE gentle, wooded countryside of Hertfordshire is increasingly the victim of London encroachment, particularly in its southern half where the village of Aldenham lies, now swallowed up in Watford's ugly suburban sprawl. But Aldenham's long, well-proportioned parish church of St John the Baptist still stretches out impressively beyond the village green and shows many of the characteristic features of Hertfordshire's old churches, from the west tower with its stair-turret rising above the battlements and its exceptionally thin, oak-shingled spire – known as a Hertfordshire spike – to the flint and stone-dressings of the exterior. The church's building history extends through the Middle Ages, much of it being thirteenth and fourteenth century, though a window in the south aisle remains from Norman times; restoration in the late nineteenth century and again after bombing in 1940 gives the church a considerably sprucer if less romantic look than the artist's view.

Within is a wealth of brass memorials, less obvious for their intrinsic beauty than for reflecting dress fashions through the centuries – and the large families of the past. The churchyard is also interesting for its many and varied tombstones, though the painting was done before an enterprising Watford baker removed a few to line his ovens, his well-baked bread marked thereafter 'Sacred to the Memory' and slack-baked '*Requiescat in Pace*'.

Henry Edridge entered the Royal Academy Schools in 1784, and was particularly admired by Reynolds. He became known chiefly as a portraitist, but as *Aldenham Church* shows he was equally at home with rustic landscape scenes. He spent much of his early life with Dr Monro, Girtin and Hearne at Bushey, Hertfordshire, only a few miles from Aldenham, and was buried in Bushey churchyard, near Monro and Hearne.

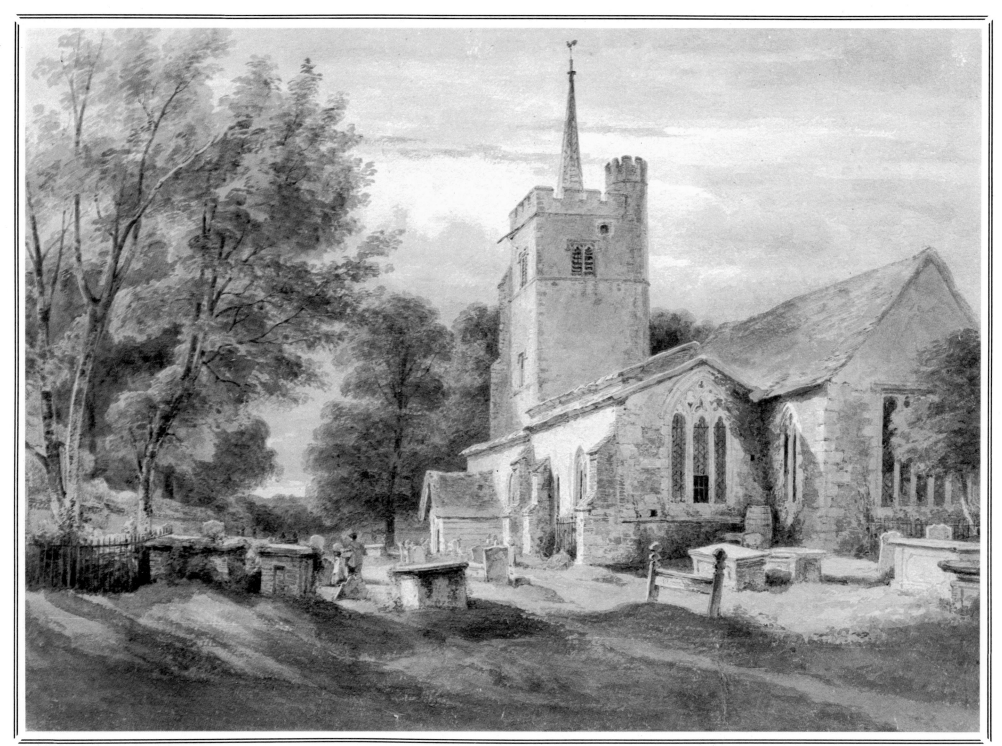

ALDENHAM CHURCH, HERTFORDSHIRE

Henry Edridge

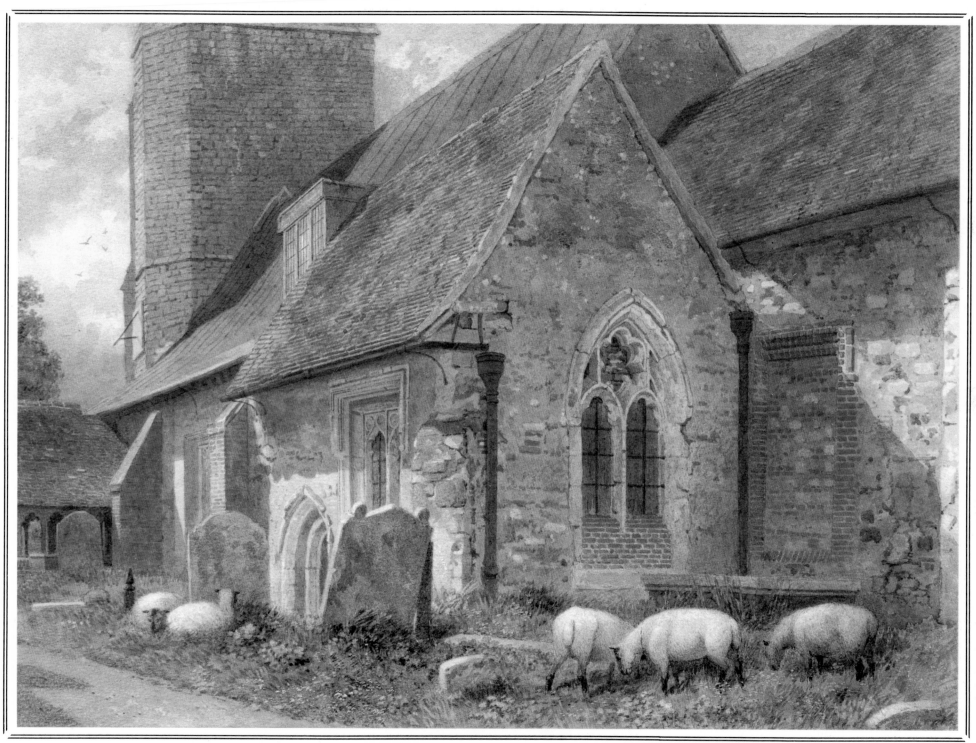

HESTON CHURCH, MIDDLESEX

John Wykeham Archer

Heston Church, Middlesex

John Wykeham Archer (1808 – 64)
264 × 365mm. 1874 – 3 – 14 – 466

IN the 1960s the old Borough of Heston became part of a 'viable unit' making up the Borough of Hounslow in the densely populated county of Middlesex. Its parish church of St Leonard's stands forlorn and isolated amid seemingly endless suburbia, a reminder of a very different past when Heston was rich farmland, famous for its wheat. The church dates back to the fifteenth century but it was almost totally rebuilt with Victorian restoration fervour in 1866, shortly after this painting was done. However, its late-fifteenth-century tower, though much restored, remains as one of the finest examples of Middlesex Perpendicular church towers, and is topped by a stair-turret (outside the view of the painting). The impressive west door is also genuine, and the west porch and lych gate, restored from old materials, retain much of their original charm. Inside the church is a delightful, if also much restored, octagonal oak font of about 1500 and an exquisitely designed monument to Robert Child, who died in 1782. He was the son of the owner of the nearby great house of Osterley Park, which was completely and superbly redecorated by Robert Adam in the 1760s, and Heston's excellent monument is signed by Robert Adam and a fellow-craftsman, P.M. van Gelder.

John Wykeham Archer began his career as an engraver in the city of his birth, Newcastle-upon-Tyne. In 1831 he made his home in London where his interests turned almost exclusively to watercolour painting. He was commissioned first by William Twopenny and later by the Duke of Northumberland to draw the old buildings in London. The collection of his drawings is now recognised as an invaluable record of a city severely ravaged both by war and the hand of the property developer. *Heston Church, Middlesex* shows that Archer was no pedestrian topographer but an artist with a unique feeling for architecture and masonry.

York Minster

Thomas Girtin (1775 – 1802)
216 × 301mm. 1855 – 2 – 14 – 11

YORK is the giant among England's medieval cathedrals and, after Canterbury, the most historic. The see of York was founded in 627 and the Minster stands on the site of the fortress headquarters of Roman York. The early wooden and stone cathedrals have long disappeared, and the vast and splendid Gothic building seen today is a complete replacement, made between 1220 and 1472, of the Norman Cathedral.

This view of it from the south-east shows the great south transept and choir, the massive central tower giving some idea of the breathtaking sense of power and limitless space of the central crossing within. To the right of the splendid, cliff-like east front is the shadowy outline of the Minster's beautiful polygonal chapter house, whose superb wooden vault is a masterpiece of carpentry engineering. The original stained glass fills the enormous Perpendicular east window, the size of a tennis court, and forms but part of York's glorious collection of stained and painted medieval glass which makes the interior glow.

After the dramatic full-scale rescue operation of 1967–72, the Minster has emerged, stabilised, in all its grandeur, the true honey-colour of its limestone restored by cleaning. It is best seen today from the top of the old city walls, overpowering in its dignity and sheer scale the old and new streets about it.

Thomas Girtin, son of a brushmaker, was born in Southwark. When he was thirteen he became apprenticed to Edward Dayes. Between 1794 and 1799 Girtin and Turner spent many evenings together at the house of Dr Monro, copying drawings by early English artists, notably J. R. Cozens. In 1794 Girtin started the first of his extensive sketching tours, concentrating on castles and cathedrals. *York Minster* shows his lightness of touch and the warmth of his colouring most sensitively expressed in the Cathedral itself. A brilliant and industrious artist, Girtin, had he lived, would have complemented Turner as a leading figure of the British School.

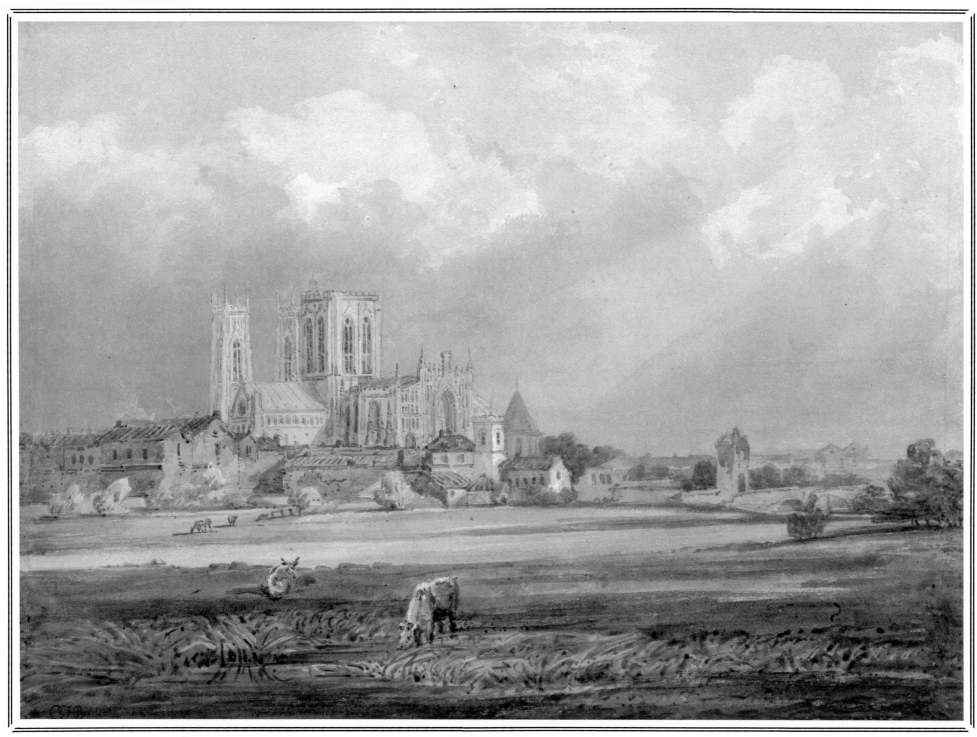

YORK MINSTER

Thomas Girtin

St Albans Abbey

Peter De Wint (1784 – 1849)
252 × 367mm. 1958 – 7 – 12 – 344

THE Abbey Church of St Albans, which became a cathedral in 1877, looms above the surrounding town, a symbol of the power its monks long held over the lives of the townspeople. It is named after the Roman soldier Albanus, the first Christian martyr in Britain, who was killed shortly after 300 on the hill where the Abbey now stands and which overlooked the then-famous Roman city of Verulamium. Seven centuries later Paul of Caen was appointed Abbot of St Albans and, dismissing his Anglo-Saxon predecessors with Norman contempt as *rudes et idiotas*, he set about replacing the old Saxon Abbey, using bricks plundered from the ruins of the Roman town.

His massive, severe structure – the square tower encloses a cavernous space from which runs an immensely long nave with thirteen bays – is largely what is seen today and it still conveys in its harsh purity the greatness of the Abbey during the Middle Ages, when it wielded vast economic power and enjoyed royal and papal privileges. After the Dissolution of the Monasteries, the Abbey fell into increasing disrepair and it survives now only because of the restoration work, however drastic and crude, of its Victorian benefactor Lord Grimthorpe. De Wint's painting shows the Abbey untouched by Lord Grimthorpe's heavy hand but the Abbey's imposing presence is hardly diminished today, whether seen from the town or from the sweep of open land to the Cathedral's south.

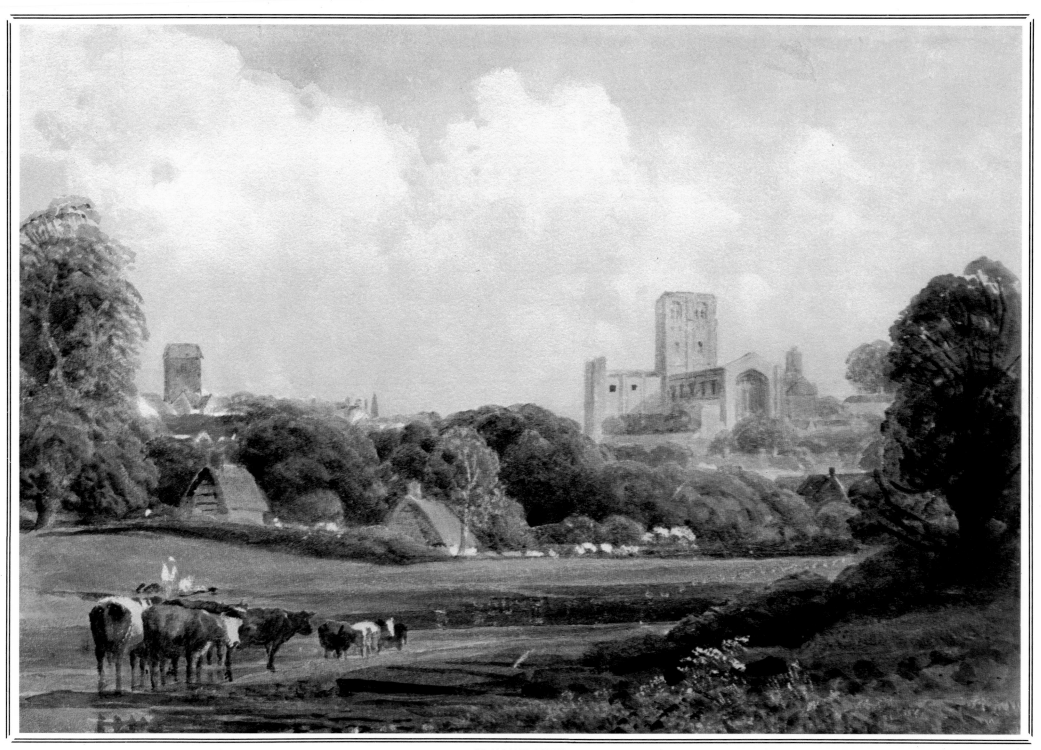

ST. ALBAN'S ABBEY

Peter de Wint

York

John Varley (1778 – 1842)
219 × 472mm. 1859 – 5 – 28 – 136

SEEN from the south across the River Ouse, the looming grey outline of York Minster gives some idea of the huge scale on which this cathedral was consciously built. Its size – York is the largest of all England's cathedrals – is matched by the harmony of its architectural styles; even though it took from the early thirteenth century to the late fifteenth century to build, York Minster is visually in the Gothic style of the later Middle Ages.

At its western end two Perpendicular towers, seen in the painting, rise in splendour above the vast west front, giving a sense of proportion to the enormous and stunningly beautiful west window. Within, the great nave makes a fitting approach to the Cathedral's outstanding feature – the central crossing. Here, in a sudden explosion of light, the vaults rise to over 185 feet to form a vast, stone-enclosed space that seems to stretch to infinity. For centuries the massive crossing-piers groaned under the weight, so that the Lantern Tower was never topped by the graceful pinnacles seen on the western towers, and when the tower began to move on its foundations in the 1960s, it took considerable modern engineering skills and hundreds of tons of concrete to meet the challenge of medieval engineering. Now that it is safe and free of scaffolding, York Minster can be fully appreciated in all its ecclesiastical power and magnificence.

John Varley was a leading watercolourist of his generation and an outstanding teacher. Artists such as John Linnell, W. H. Hunt and Turner 'of Oxford' came to him for instruction and he encouraged his pupils to develop individual styles. A founder member of the Old Water-Colour Society, he was responsible for several influential publications on drawing. Varley was also an enthusiastic astrologer and published a treatise on *Zodiacal Physiognomy* in 1828.

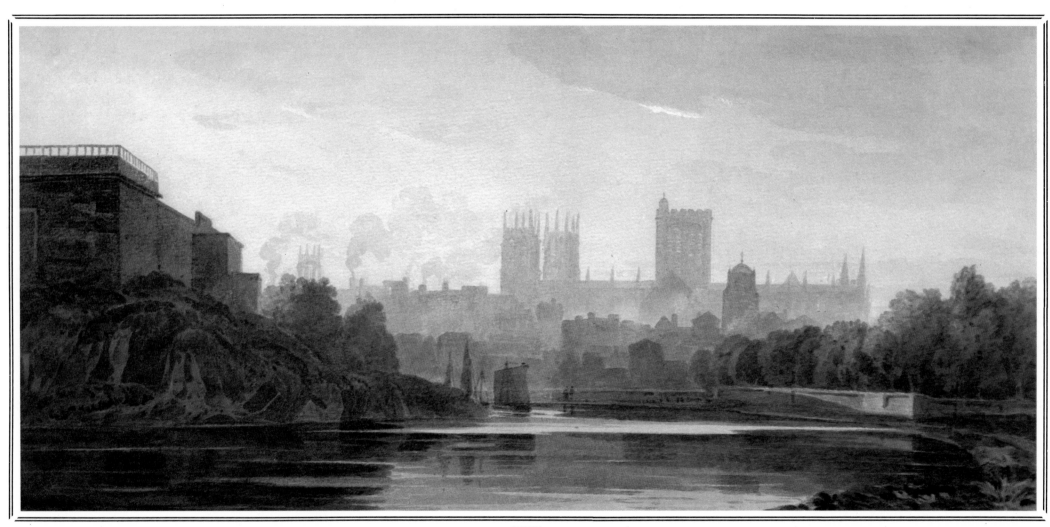

YORK

John Varley

St Paul's Cathedral

John Sell Cotman (1782 – 1842)
196 × 321mm. 1859 – 5 – 28 – 122

THE magnificent dome of St Paul's Cathedral topped by its slender lantern and gold cross is still the focal point of the City's skyline, despite the barbaric results of modern property speculation. Now, skyscrapers obscure the views close in and diminish the effect of the once spectacular view from across the river when the silhouette of Sir Christopher Wren's Cathedral stood against the sky in solitary splendour, with the delicate spires of Wren's fifty-one City churches dotted about it.

The Cathedral was commissioned after the Great Fire of London of 1666 had destroyed the old St Paul's. It took half a century to complete, during which Wren battled constantly with technical and financial problems, parliamentary complaints, official interference, and strikes by the Portland quarrymen who were providing the stone. But he lived to see his vast prodigy cathedral completed, as impressive from afar as from within, where the awe-inspiring volume of space and stunning perspectives are enhanced by the beauty of the plaster and metalwork, the fine woodcarving, and the wall and ceiling paintings.

Over the centuries the Cathedral has been the majestic setting for great state ceremonies and, appropriately, the tombs of Nelson and Wellington lie within it, alongside many others of the nation's famous. Almost miraculously, the devastating Blitz of 1940 failed to wipe out St Paul's, which became a symbol of the nation's endurance as each night 'the dome seemed to ride the sea of fire like a great ship lifting above smoke and flame the inviolable ensign of the golden cross'.

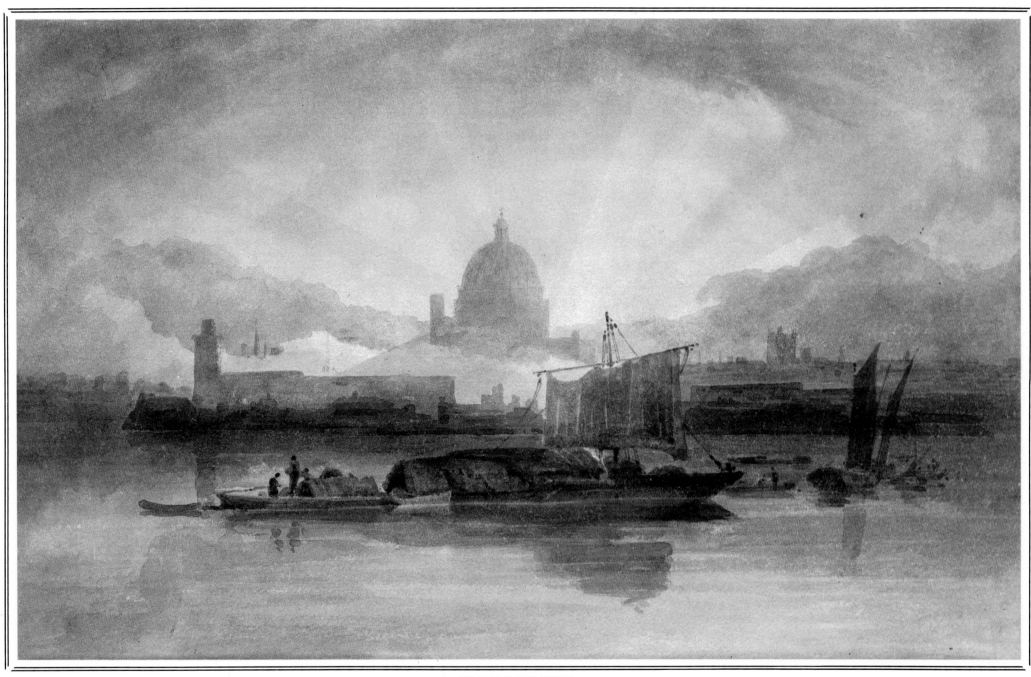

ST. PAUL'S CATHEDRAL

John Sell Cotman

Lincoln

Peter De Wint (1784 – 1849)
660 × 985mm. 1958 – 7 – 12 – 341

PERCHED dramatically on top of the limestone ridge that drops two hundred feet to the River Witham below, Lincoln Cathedral is a spectacular sight; before the enormous spire of its central tower blew down in a storm in 1549, it could be seen from as far away as East Anglia. The town, whose origins go back much further than the Roman hill-fort established on the plateau in about AD 50, now spills down from around the Cathedral to extend well across the river, on which pleasure and working boats still traffic busily.

The bulk of the Cathedral seen today, described by John Ruskin as 'out and out the most precious piece of architecture in the British Isles', was rebuilt in the thirteenth century after an earthquake in 1185 had split apart the first Norman building. Of this the heart of the sensational west front remains; entering from here the effect of the long tunnel of the nave stretching into the far distance is overwhelming. The Angel Choir with its glorious profusion of wood and stone carving provides the astonishingly beautiful climax to the interior, which includes immense and magnificent transept windows. The 'Dean's Eye' of the north is complete with the original stained glass – despite the only too successful efforts of Puritan fanatics in the Civil War to destroy the Cathedral's glass.

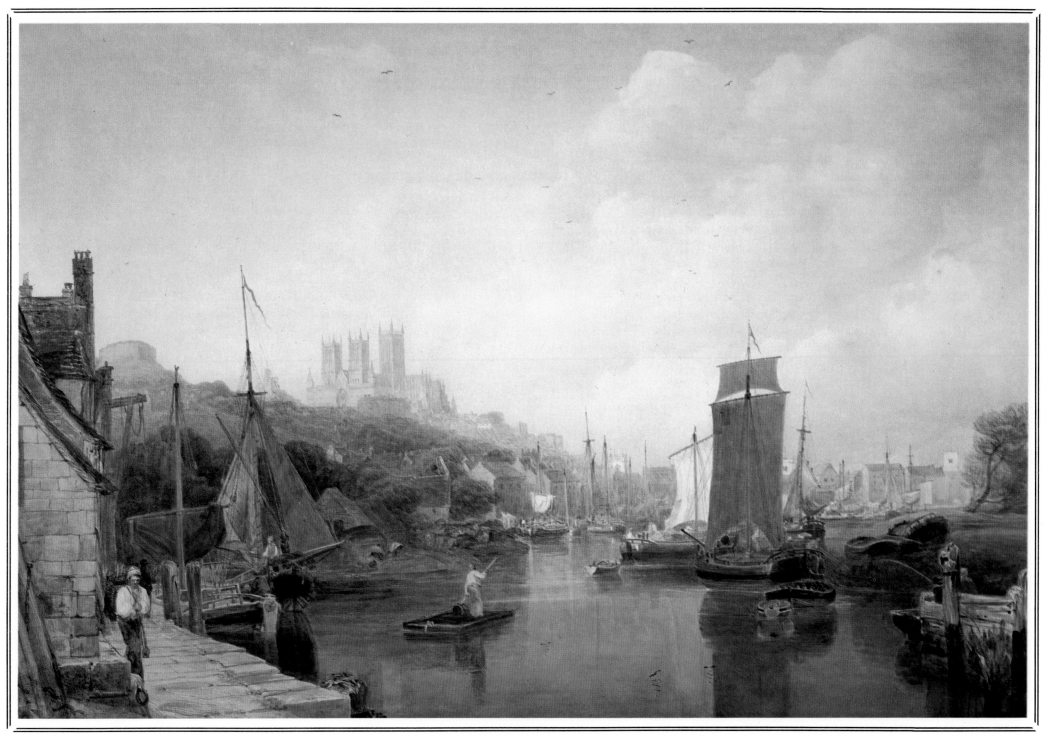

LINCOLN
Peter de Wint

FRONT COVER

Stoke-by-Nayland Church

John Constable (1776 – 1837)
144 × 195mm. 1888 – 2 – 15 – 29

STOKE-BY-NAYLAND'S splendid parish church of St Mary's dominates the landscape for miles around. It stands on a ridge overlooking the River Stour in the beautiful, secluded West Suffolk countryside where Constable grew up and which inspired many of his paintings. The magnificence of the church – much too large for the local population now as in the past – stems from the sudden wealth of cloth merchants in the fourteenth and fifteenth centuries when sheep-rearing areas like Suffolk made large profits from wool exports. This new-found wealth was displayed in St Mary's, a tribute both to God and to the clothiers' own importance. Many memorials within the church bear clothiers' trade marks and the impressive, 120-foot-high west tower, with its large buttresses and decorated battlements and pinnacles, was built in the mid-fifteenth century with money bequeathed by local merchants. The south porch, seen in this painting, has beautifully carved wooden doors and carries the arms of the Howard family, whose famous members include two of Henry VIII's wives, Catherine Howard and Anne Boleyn. When the west doors are open on a warm summer evening, the view within of the high tower-arch and fine arcades is particularly beautiful, while the view from outside, though now considerably less rustic than in Constable's day, includes many attractive sixteenth-century, half-timbered cottages and houses in the streets around the church.

John Constable was born at East Bergholt, Suffolk, the son of a prosperous millowner. In 1800 he enrolled as a student at the Royal Academy Schools and soon decided that his ability lay in landscape painting. Major works in oil, such as the *Hay Wain*, were first recognised as masterpieces not in England but in France at the Paris Salon in 1824. In 1829 Constable became the first landscapist to be elected a full Royal Academician. Constable's talents as a watercolourist lay chiefly in his understanding of colours to suggest climatic and atmospheric variation, *Stoke-by-Nayland Church* being an especially fine example.

BACK COVER *Gloucester Cathedral,* Peter De Wint